what Labs love

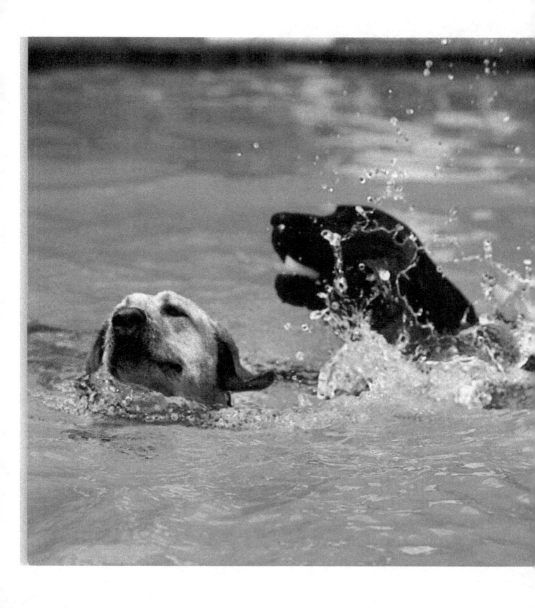

what Labs love

Photography by Ed Camelli
Text by Mike Singer

an Imprint of
Hungry Minds, Inc.
An International Data Group Company
Foster City, CA • Chicago, IL • Indianapolis, IN • New York, NY

Howell Book House
Hungry Minds, Inc.
An International Data Group Company
909 Third Avenue
20th floor
New York, NY 10022

For general information on Hungry Minds' books in the U.S., please call our Consumer
Customer Service department at 800-762-2974. For reseller information, including discounts
and premium sales, please call our Reseller Customer Service department at
800-434-3422.

Library of Congress Cataloging-in-Publication Data is available from the publisher.

ISBN 0-7645-6320-3

Manufactured in the United States of America

10 9 8 7 6 5 4 3 2 1

Book design by Edwin Kuo and Holly Wittenberg

Cover design by Edwin Kuo

pleasure for them. You say, "Let's go," and they are up in an instant, ready for anything.

How many other dogs can hunt ducks in a frozen marsh at dawn and be kissing a newborn at dusk? A Labrador Retriever is equally willing to accompany a jogger on a five-mile run or to spend an entire day at Grandpa's feet.

Any dog, or person for that matter, will love you when life is easy. But a Lab is your best buddy even on a rainy day when you're stuck inside, or when it's hot on a Monday and the bills are due. It doesn't matter to them. They'll be at your side regardless.

A Labrador will bust through briars to retrieve a pheasant, dive off a dock into unknown waters, climb a ladder. Just give the command and they obey.

Dress Labs up in ridiculous outfits and they play along. Get them revved up and they will do figure eights around you at full speed. Fill up a kiddie pool and they will frolic like three-year-olds.

Pots can be banging in the kitchen, kids can be screaming, phones ringing, and they will lie placidly until called upon.

While other dogs will jump and fret because a fence is between them and

Foreword

I've always liked dogs, pretty much any breed, color, and size—as long as it had a wet nose and a wagging tail. However, I love Labrador Retrievers. I got my first Lab in 1985 and have had a Lab at my side ever since. So, I began photographing Labs because they were there. I had just purchased a new camera, and I needed a subject on which to practice. Because there is always a Lab with me, I realized that I had a ready and willing model. But it wasn't until after I developed those first photos and really looked at them that I started to see that a Lab was much more than just a pretty face for me to love. It was then that I began to study

the qualities that, to me, make a Lab a Lab—that is, the qualities that make them such loving and lovable creatures.

A look from a Labrador transcends the language barrier and expresses an understanding that few humans can manage. Labs are amazingly sensitive to our emotions and can both revel in our joys and share our sorrows.

Labs don't know what a "bad day" is. No matter the circumstances, Labs always greet you as if they haven't seen you in a week. Every fetch of a ball, every step on a walk is unbounded

their toy, a Labrador Retriever will figure out how to go around, under, or over. They can be taught just about anything, including retrieving a cordless phone for a disabled human friend.

They are the Olympians of the dog world. They can run with the speed of a sprinter or the endurance of a miler. They can leap a distance over a ditch or up over a three-rail fence. Only gills could improve their swimming.

A two-year-old can ride them bareback or pull their tails, and they never so much as utter a faint growl. They will always give you that Labrador look when they sense that things aren't going so well for you and the bad mood will just melt away.

In essence, Labs are animals with a capacity for loving what life has to offer that is as vast as our own. And I have spent enough time with Labs to realize that, like people, Labs love simply because they can, which makes them, to my mind, the perfect dog.

Ed Camelli

Ed Camelli
Gumtree, PA
August 2000

Acknowledgments

My extreme gratitude to Bonnie for her patience and creativity. Much appreciation to Mike for giving life to the photos with his words. Many thanks to Sarah S., Joanie, Sue, Nancy, Barbara, Heidi, Sarah McD., Colby, John, Katie, Leelee, Max, Wade, Wendy, Carol, Charlotte, Sally, Jonathan, Desiree, Andrew, Brian, and Mom and Dad. A very special thank you to Ripple, Hoover, Sailor, Griffin, Morgan, Rose, Acorn, Jeffrey, and Lucy.

What do
Labs Love?

Labs Love everything!

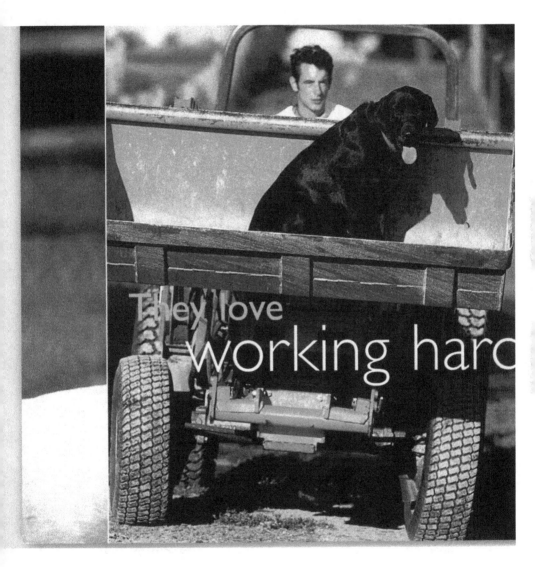

They love
working hard

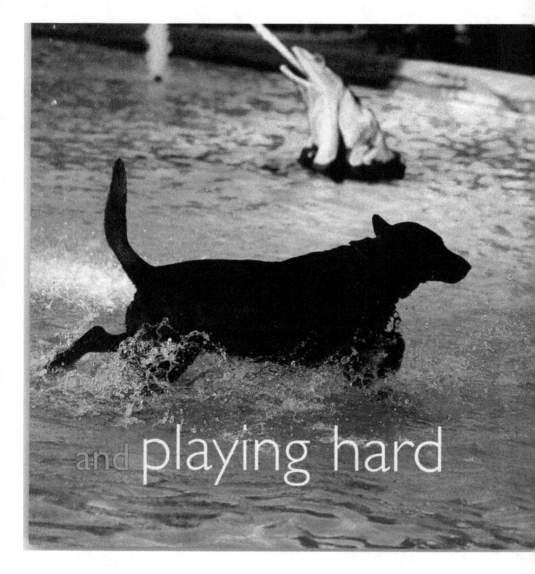

and playing hard

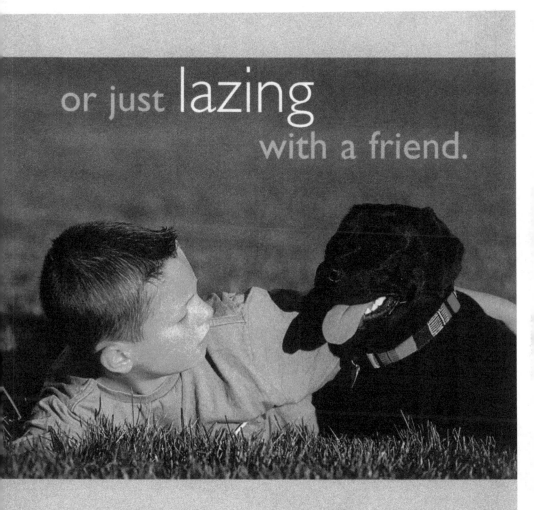
or just lazing
with a friend.

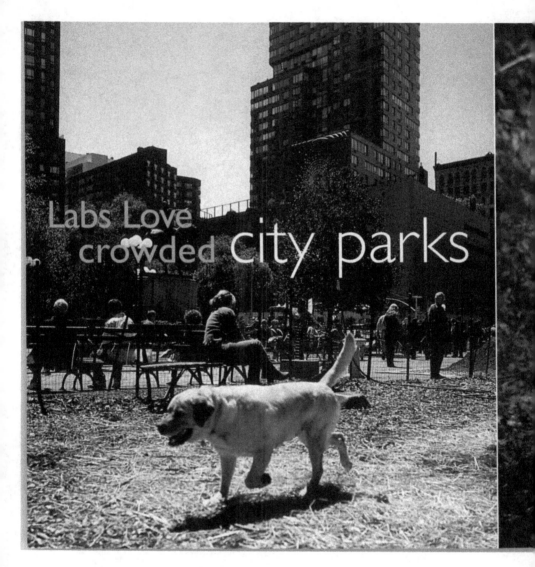
Labs Love crowded city parks

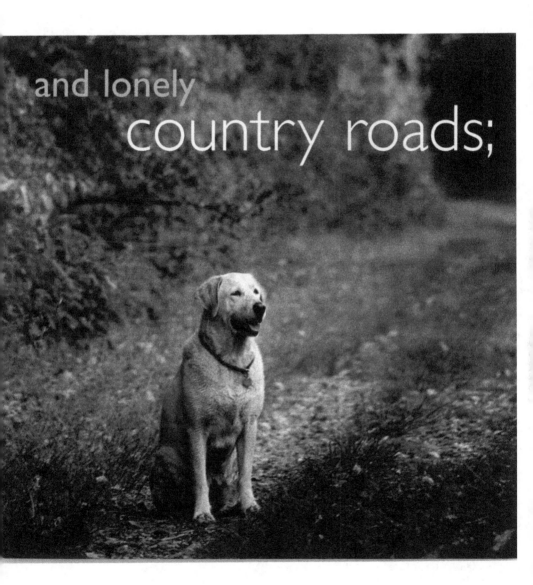

and lonely
country roads;

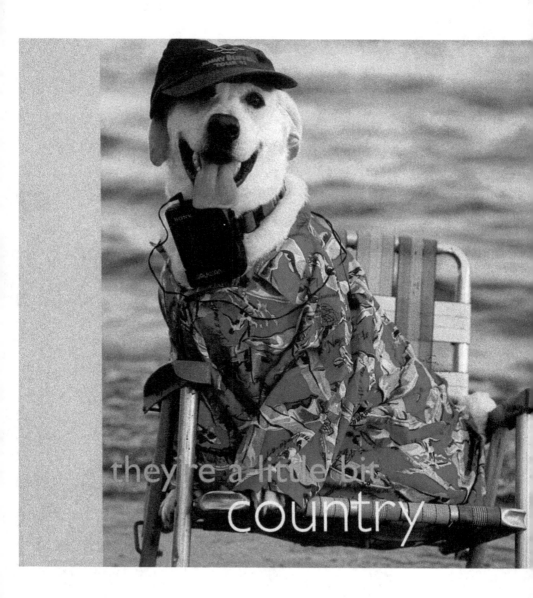

they're a little bit
country

and a little bit
rock 'n roll.

Labs Love getting
down & dirty . . .

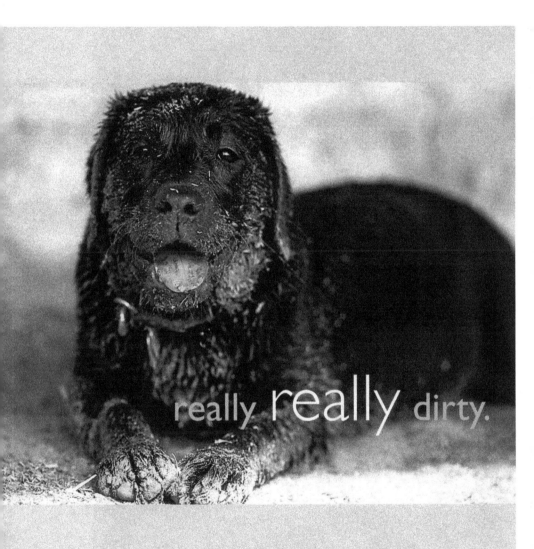

really really dirty.

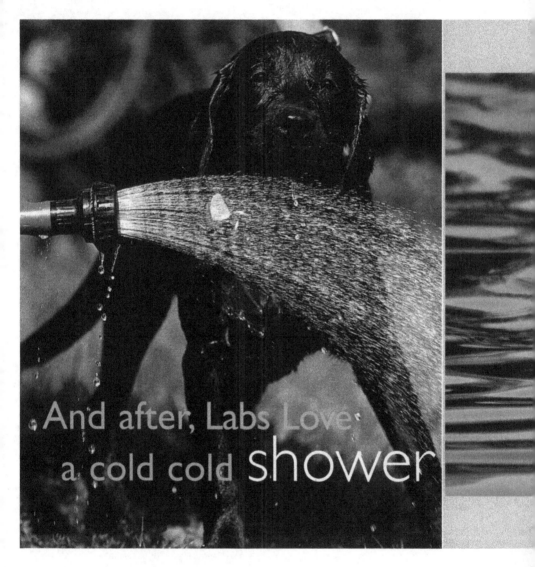

And after, Labs Love
a cold cold shower

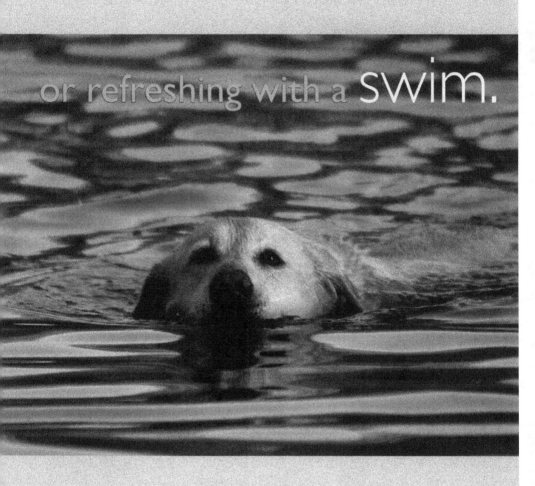
or refreshing with a swim.

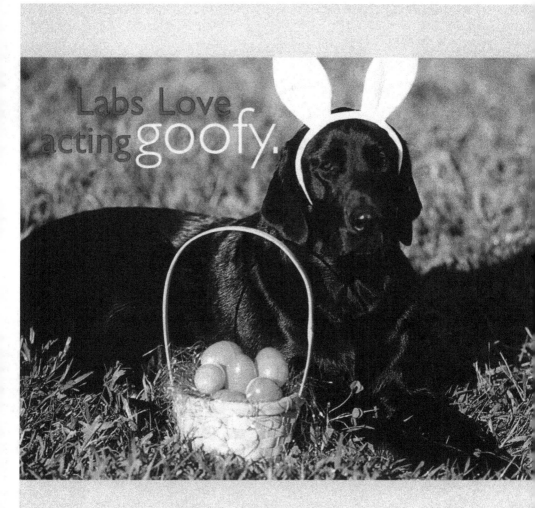

Labs Love acting goofy.

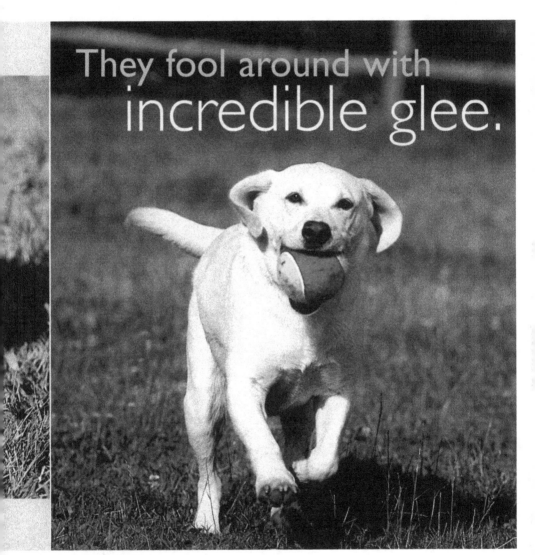

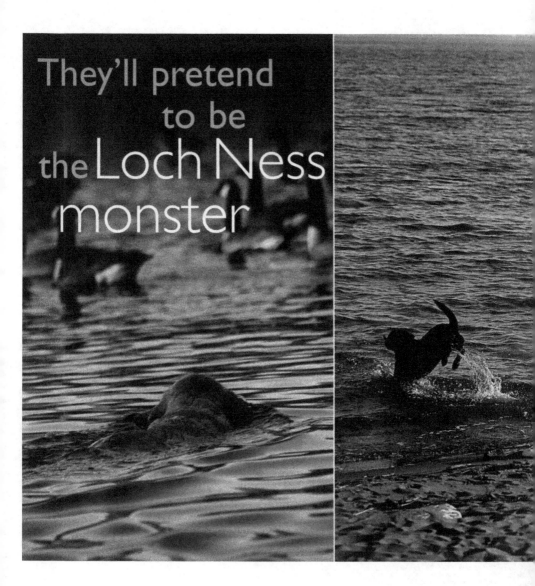

They'll pretend
to be
the Loch Ness
monster

and try to chase the sea.

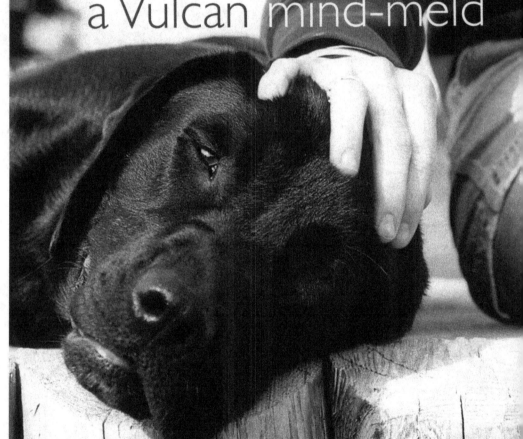

Labs even love submitting to
a Vulcan mind-meld

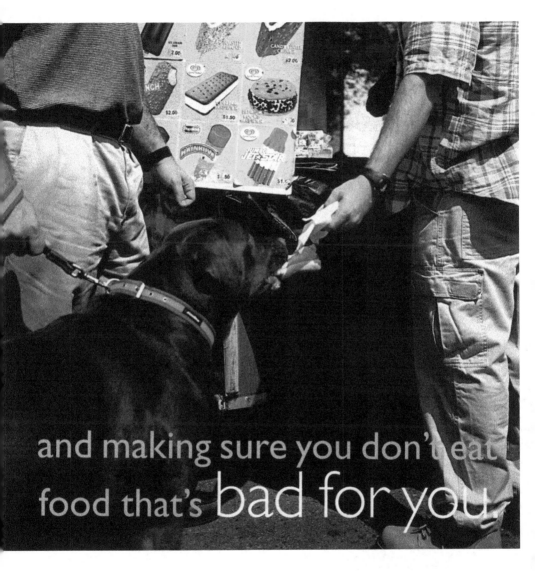

and making sure you don't eat food that's bad for you.

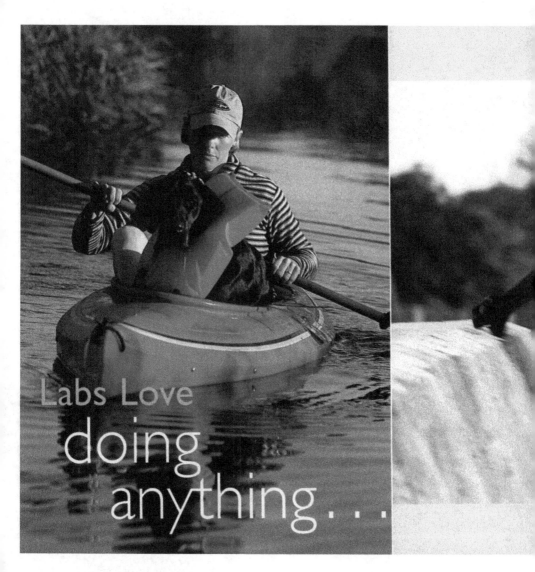

Labs Love
doing
anything . . .

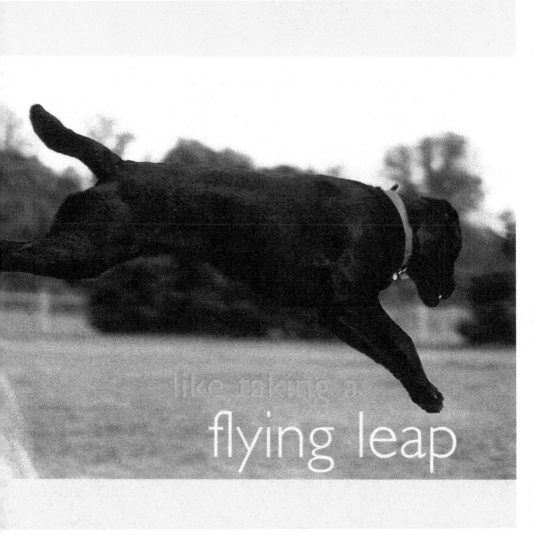

like taking a
flying leap

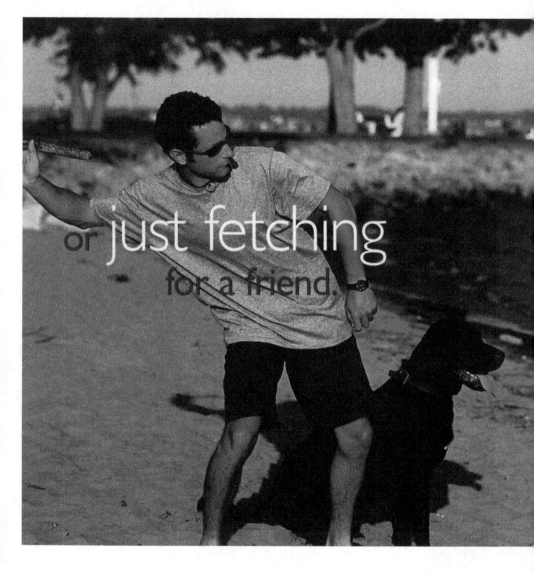

or just fetching for a friend.

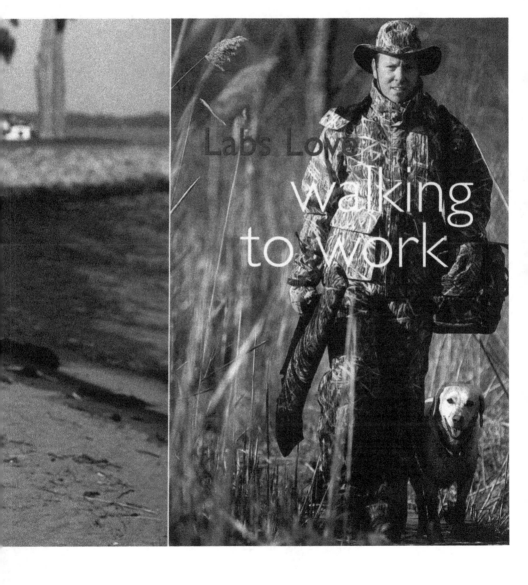

Labs Love **walking to work**

and attending
all-day meetings,

then...

taking it all in

after punching out

for the day.

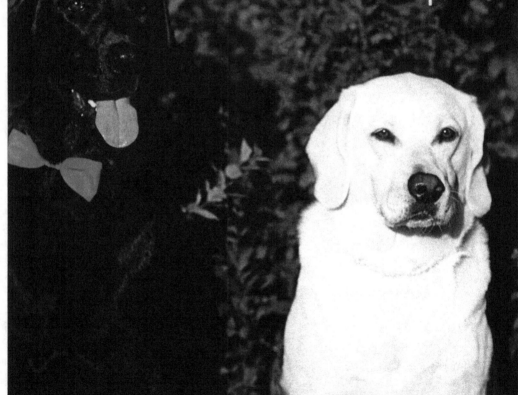
Labs Love getting
dressed up

or reading a **good book,**

but most of all,

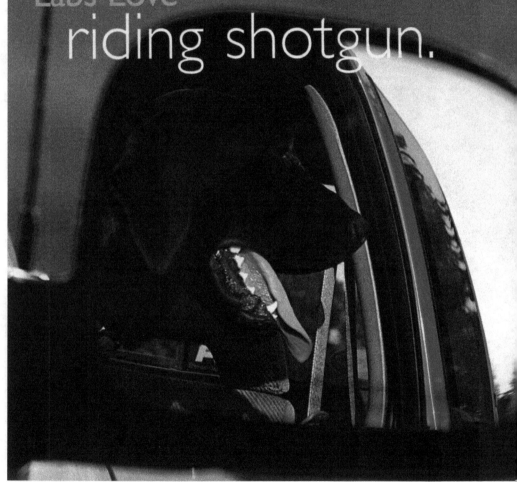

Labs Love
riding shotgun.

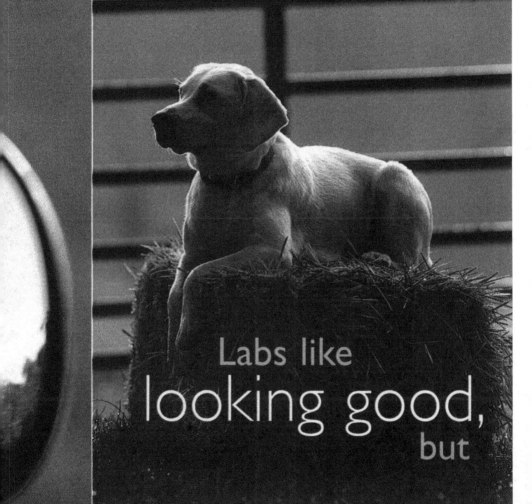

Labs like
looking good,
but

they love **looking better,** and

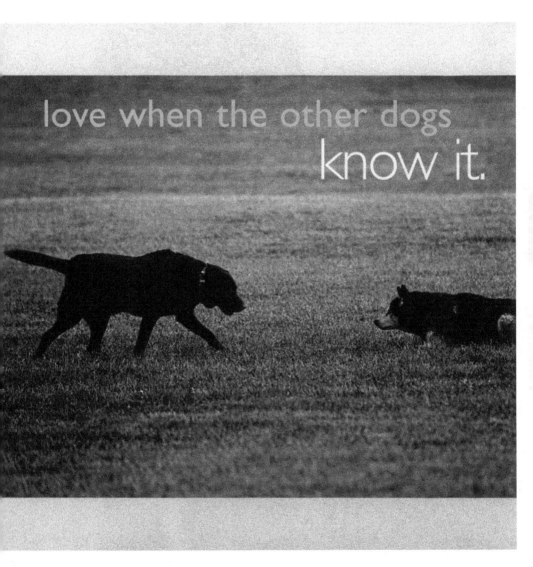
love when the other dogs know it.

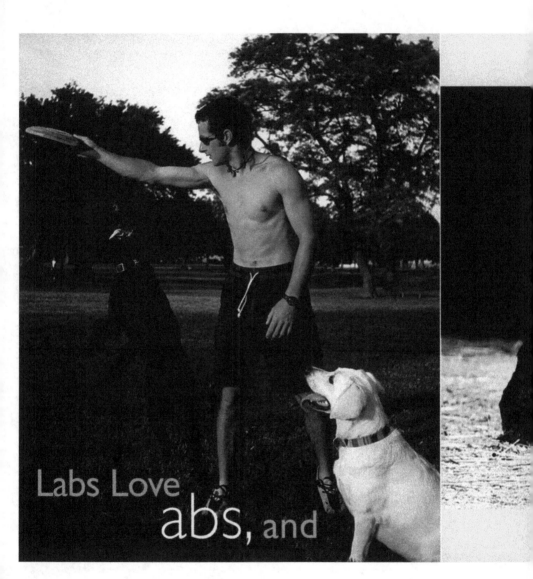

Labs Love abs, and

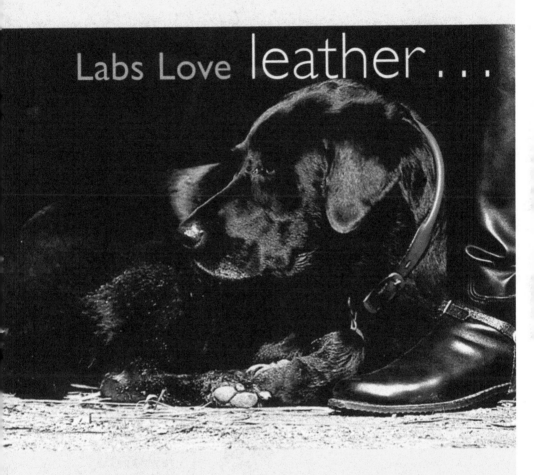

Labs Love leather . . .

Labs Love
looking good
in all kinds
of weather.

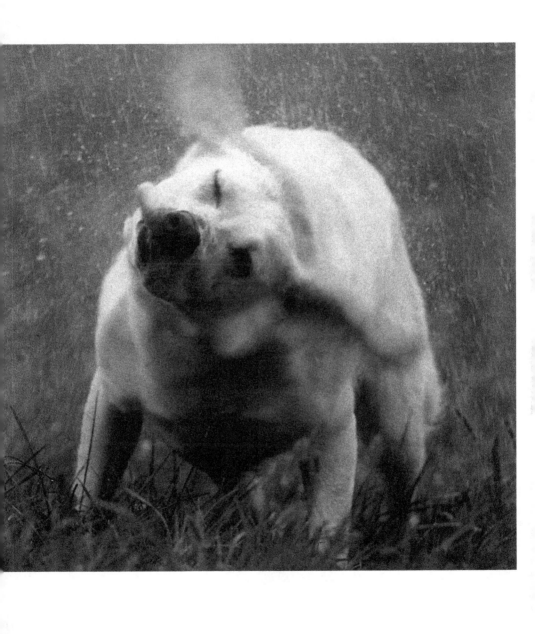

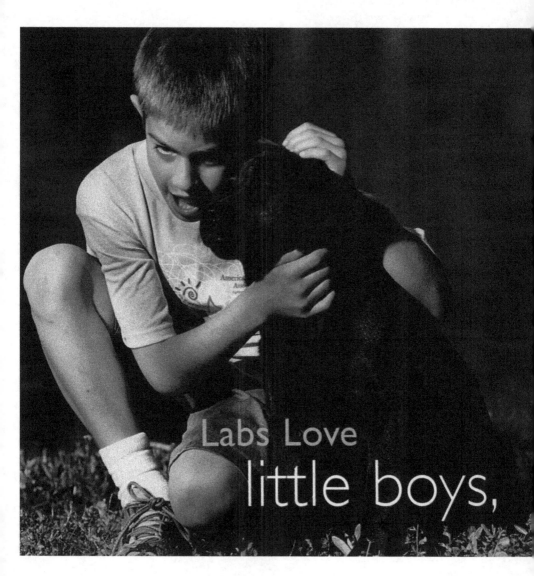

Labs Love
little boys,

Labs Love little girls,

and Labs especially Love little Labs.

Labs Love
all God's creatures . . .
great

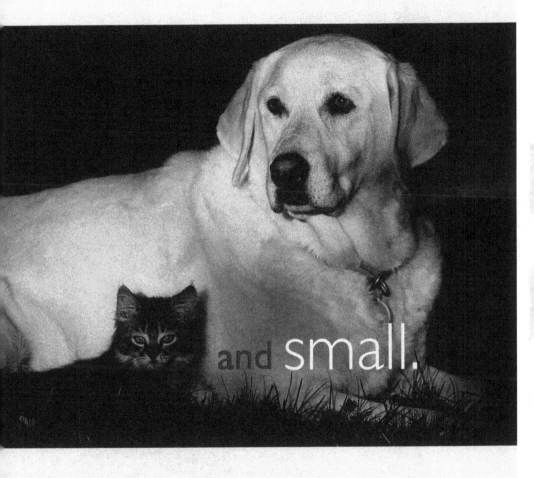
and small.

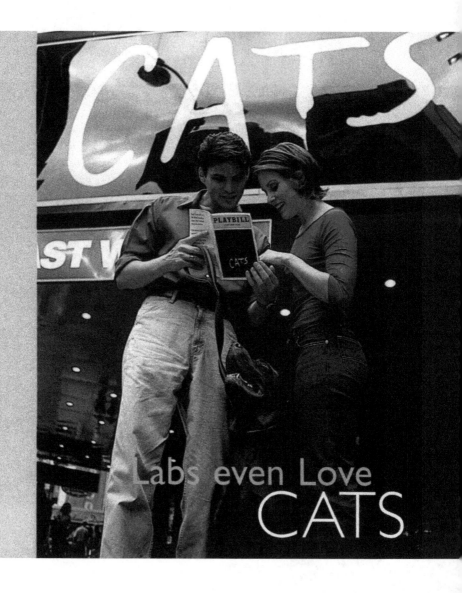

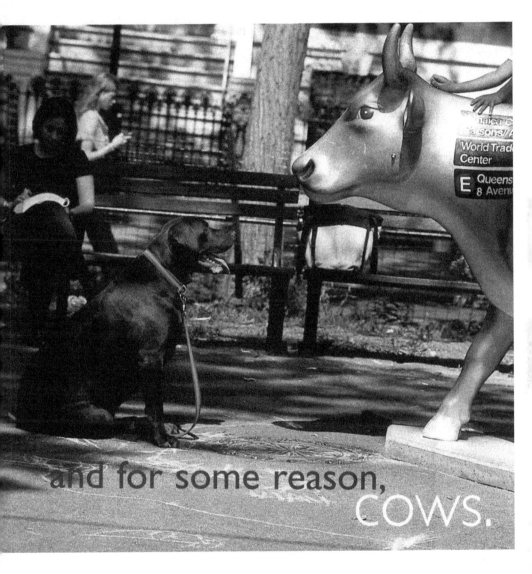

and for some reason,
COWS.

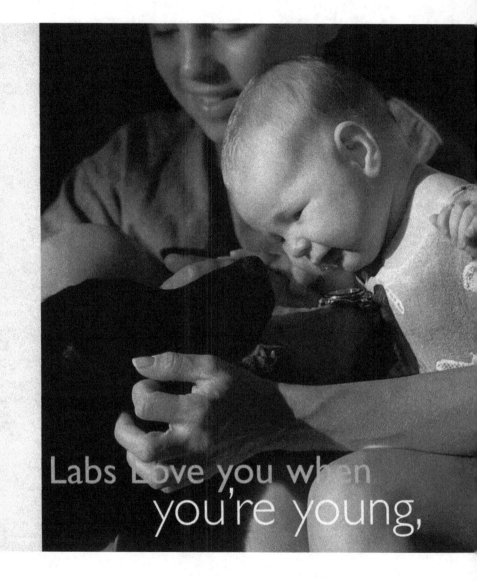

Labs Love you when
you're young,

Labs Love
you when
you're old.

Labs Love you
whether you're black,

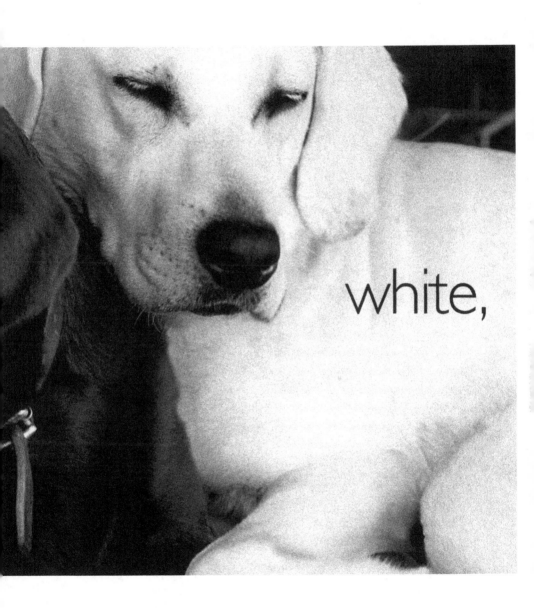

white,

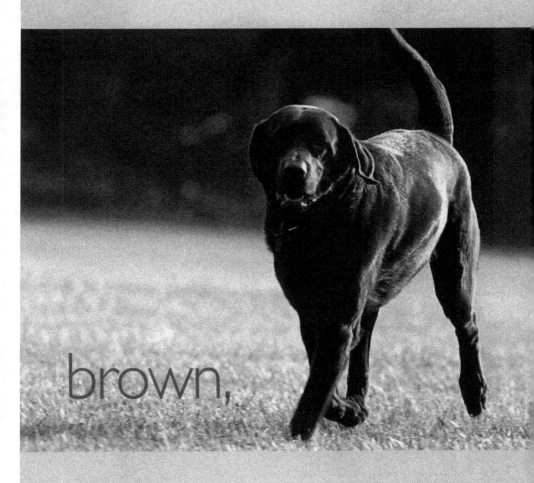

brown,

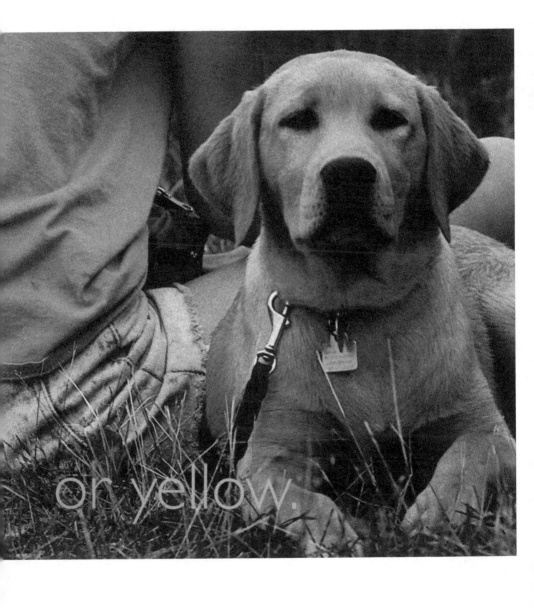

or yellow.

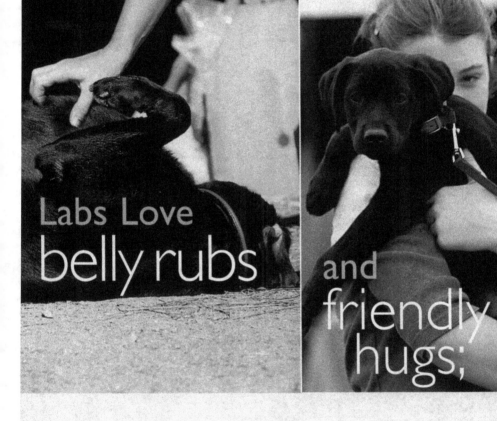

Labs Love
belly rubs
and
friendly
hugs;

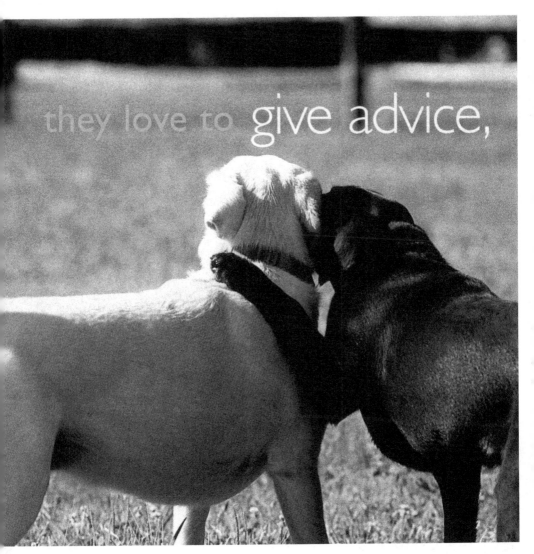

they love to give advice,

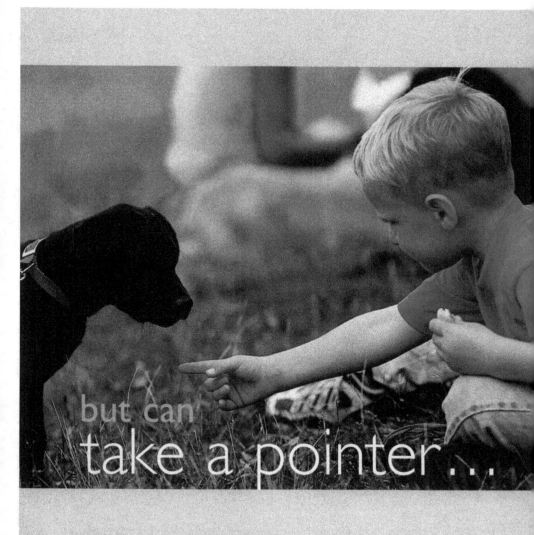

but can
take a pointer . . .

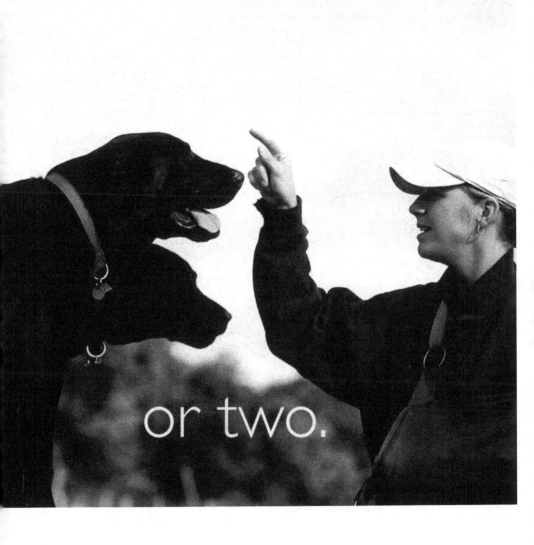

or two.

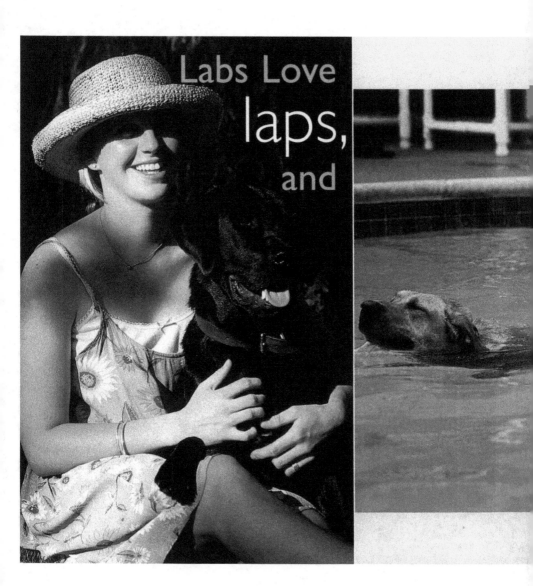

Labs Love

laps,

and

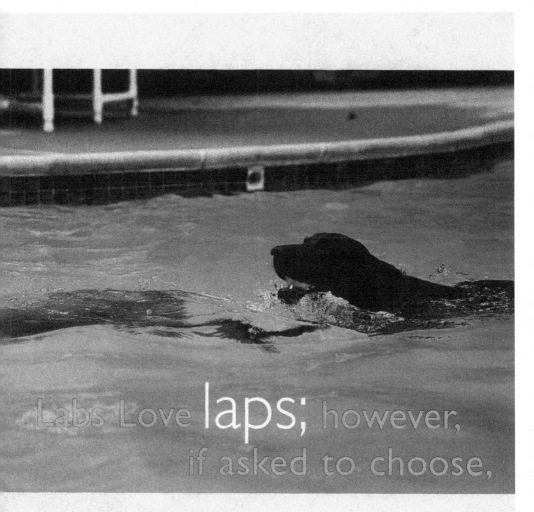

Labs Love laps; however, if asked to choose,

Labs Love lapping most.

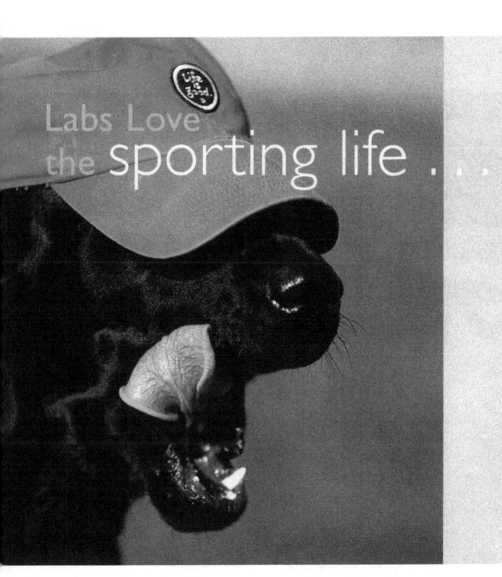

Labs Love
the sporting life . . .

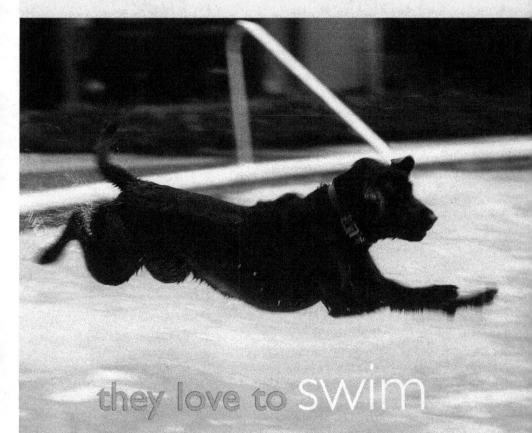

they love to swim

and love to run

Labs Love to fish

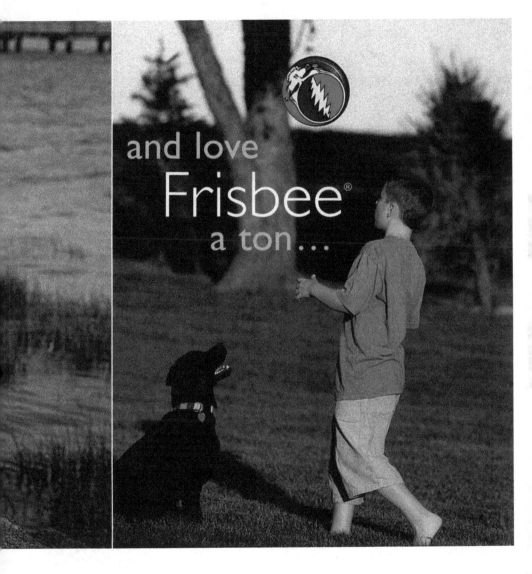

and love
Frisbee®
a ton...

Labs even Love to
water-ski

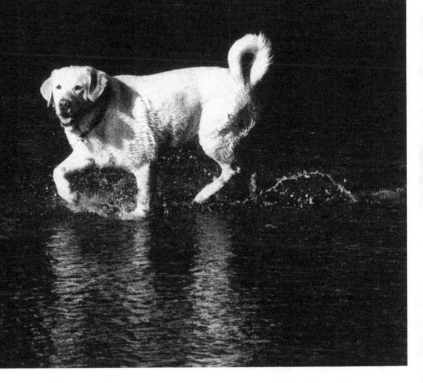

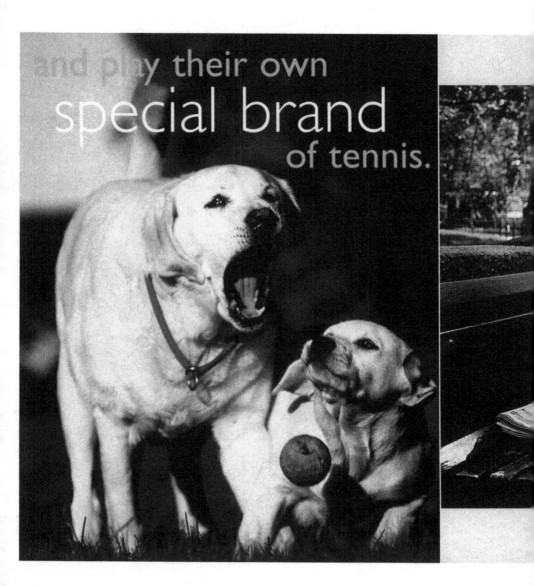

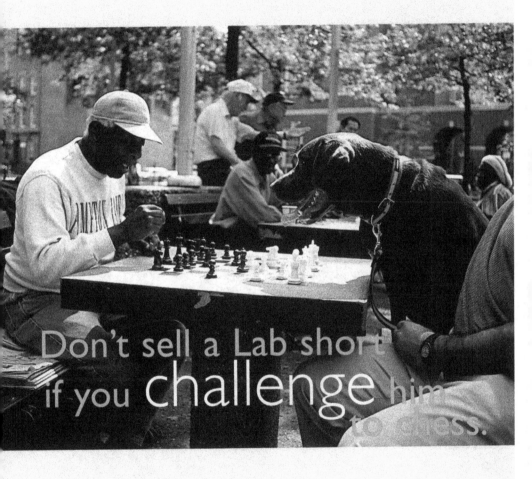

Don't sell a Lab short if you challenge him to chess.

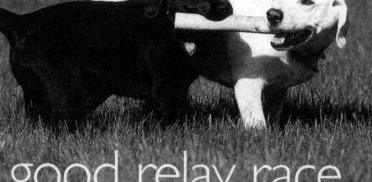

To a Lab,
 there's nothing like a

good relay race...

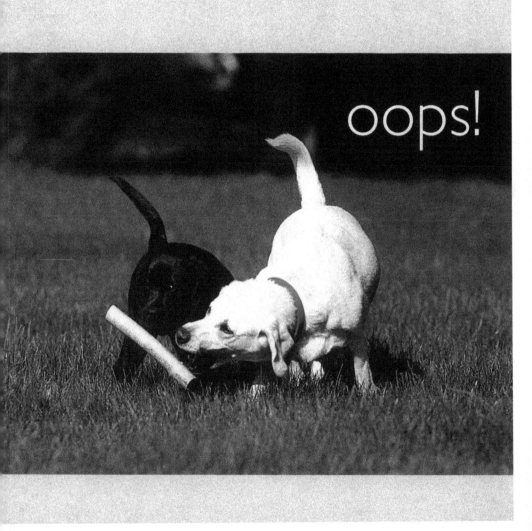

oops!

Labs Love
coaching the team

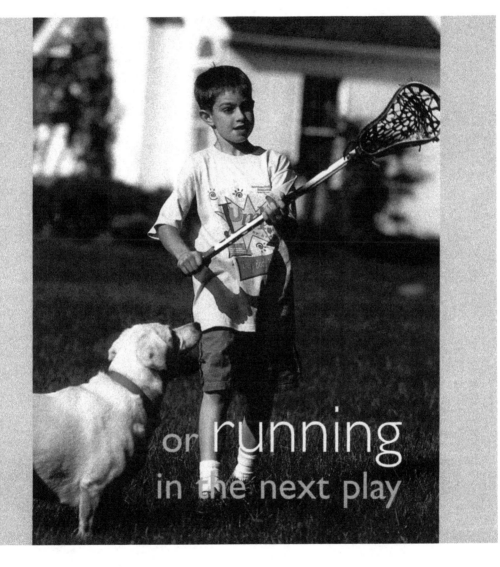

or running
in the next play

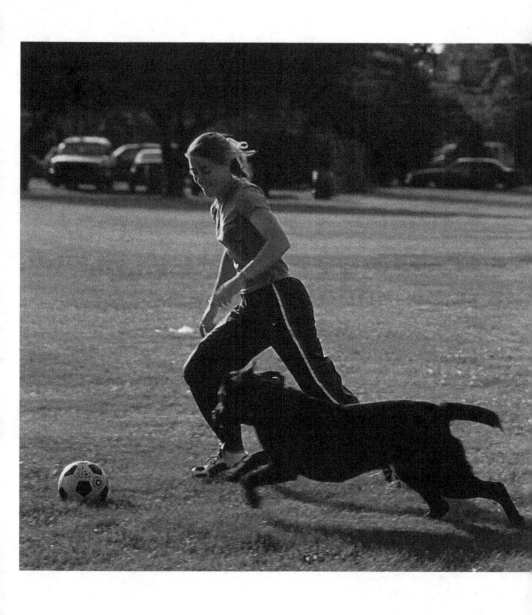

But like all **athletes** who've come **before,**

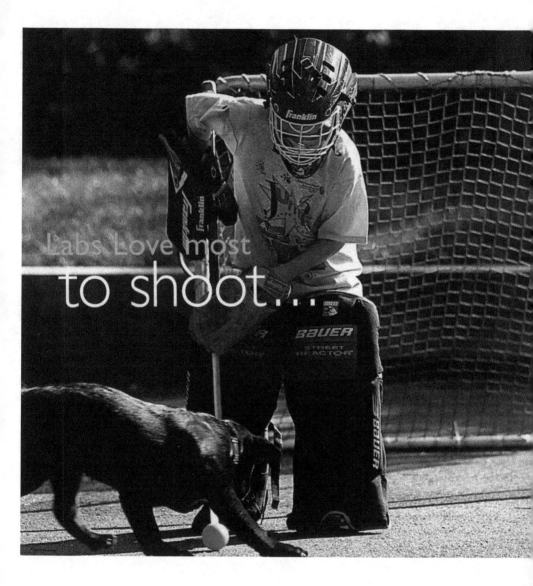

Labs Love most
to shoot...

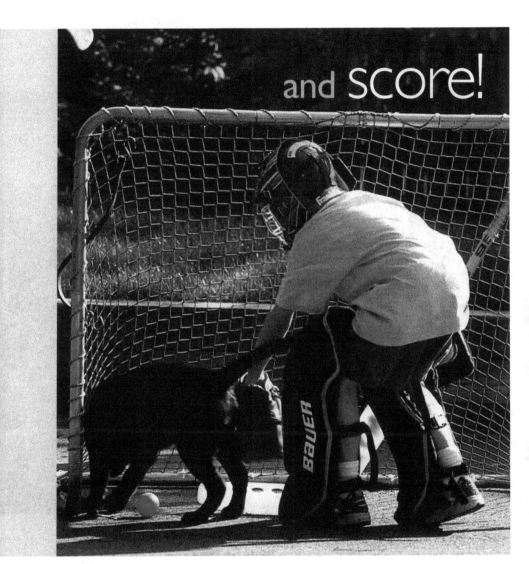

and score!

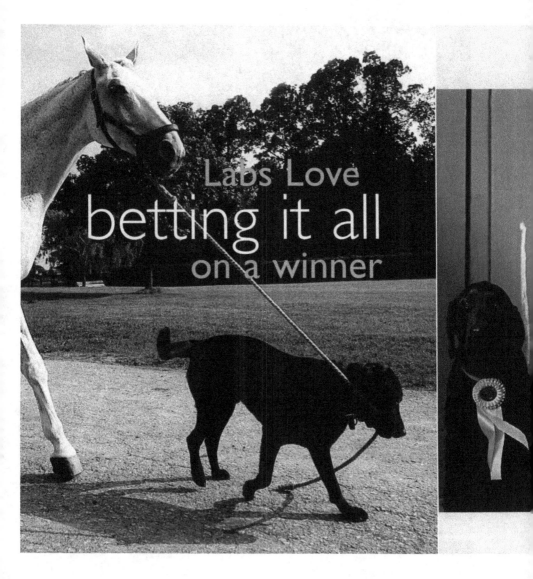

Labs Love
betting it all
on a winner

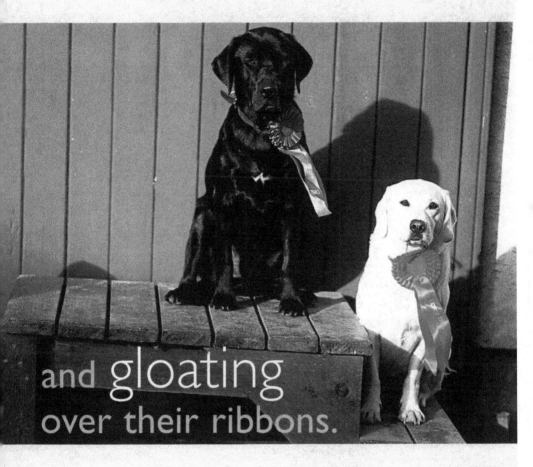

and gloating over their ribbons.

But, the prize Labs Love most is digging into dinner.

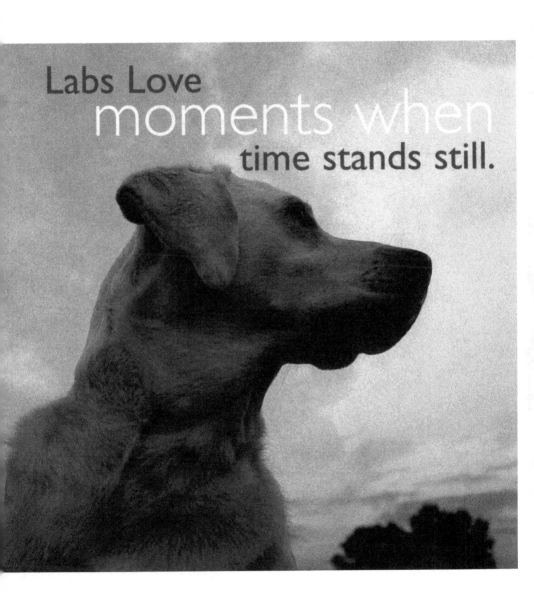

Labs Love **moments when** time stands still.

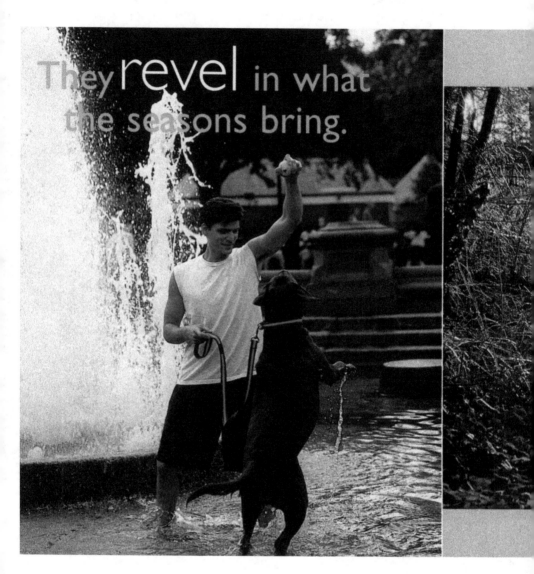

They **revel** in what the seasons bring.

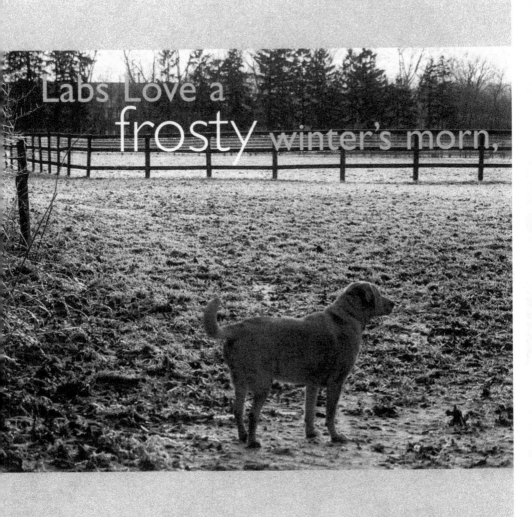

Labs Love a *frosty* winter's morn,

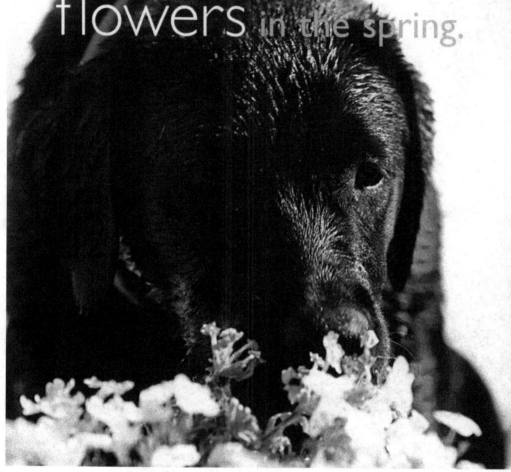

the smell of
flowers in the spring.

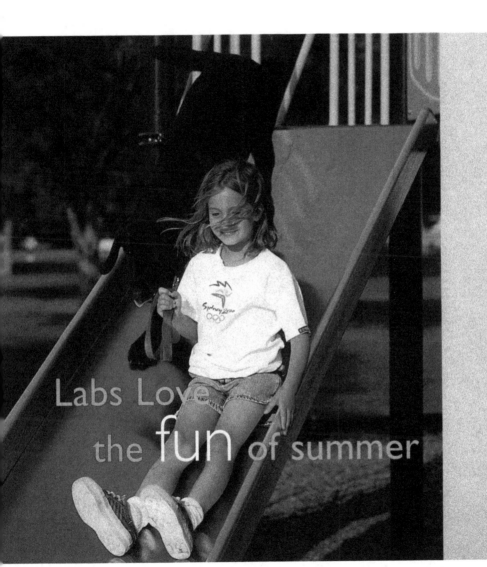

Labs Love
the fun of summer

and a

romp

through autumn leaves.

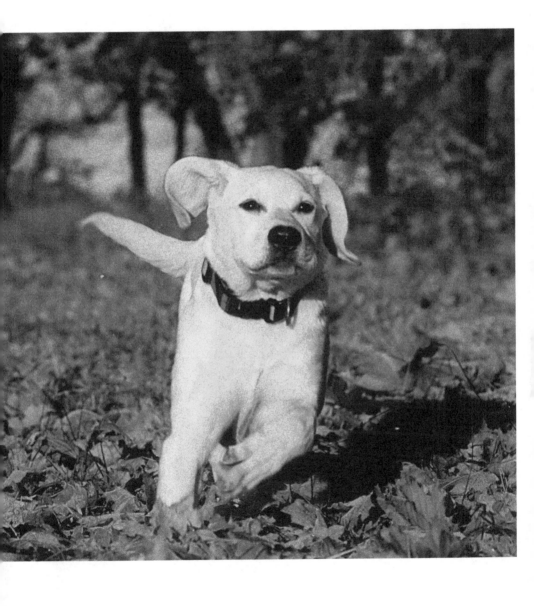

They love
the freshly fallen
snow

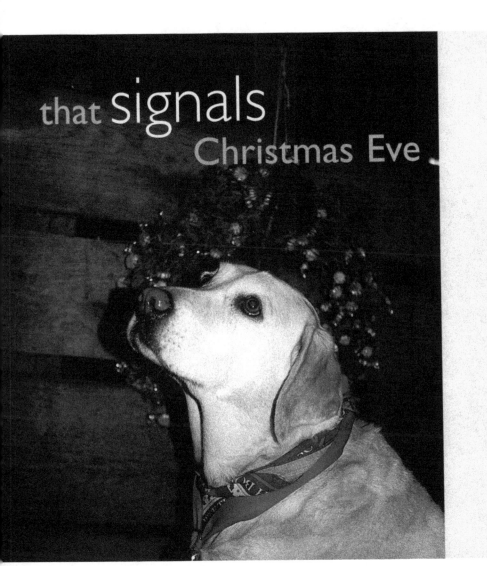

that signals
Christmas Eve

Labs Love
the holidays.

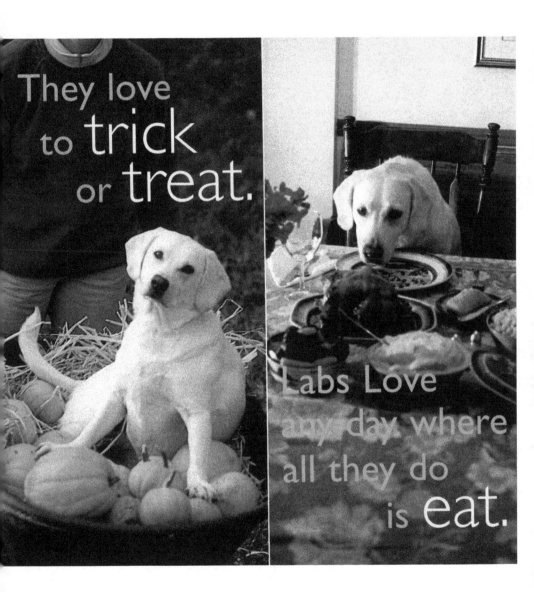

They love to trick or treat.

Labs Love any day where all they do is eat.

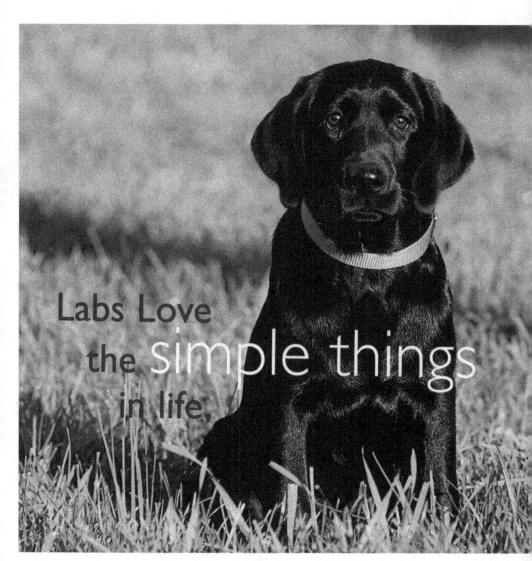

Labs Love
the simple things
in life,

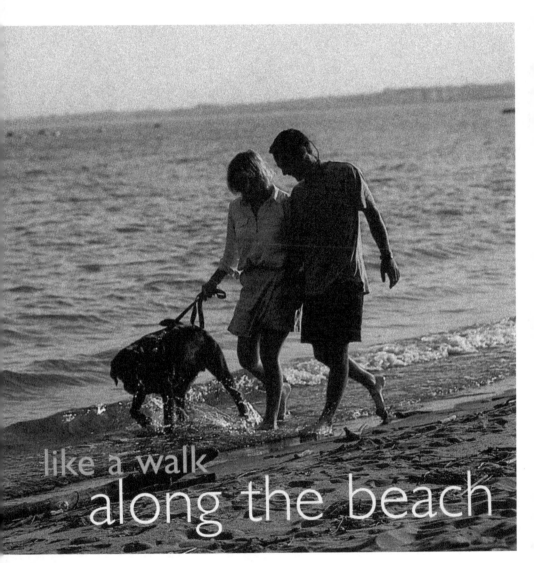

like a walk
along the beach

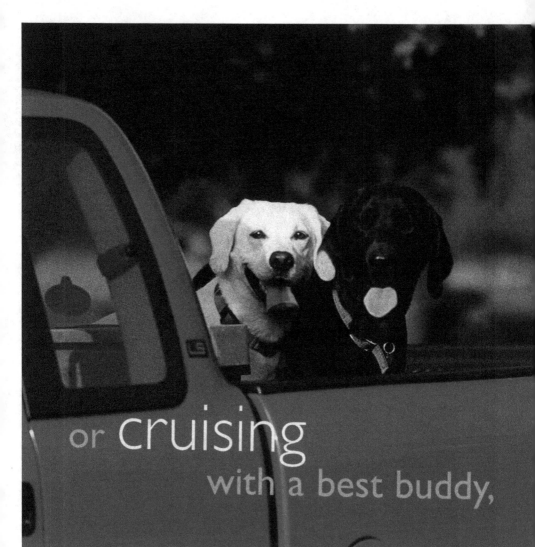

or cruising
with a best buddy,

not to mention
a good night's sleep.

Labs Love to lead

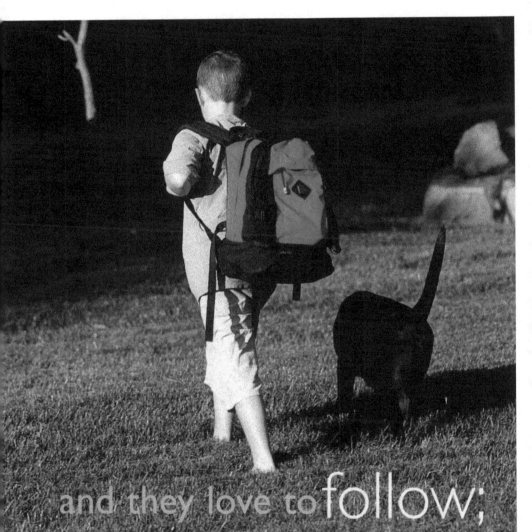

and they love to follow;

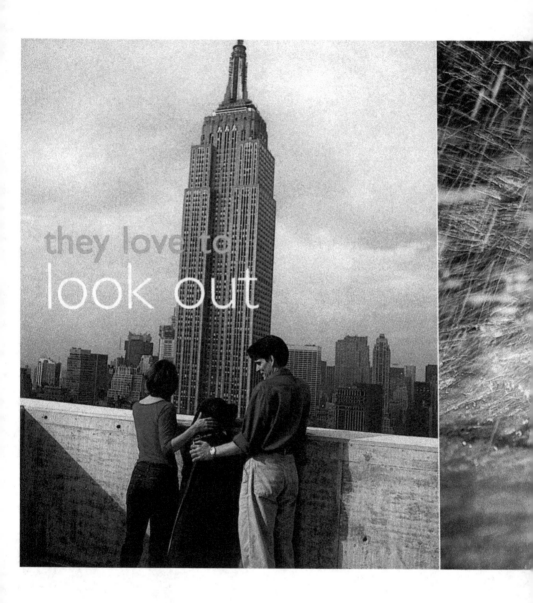

they love to
look out

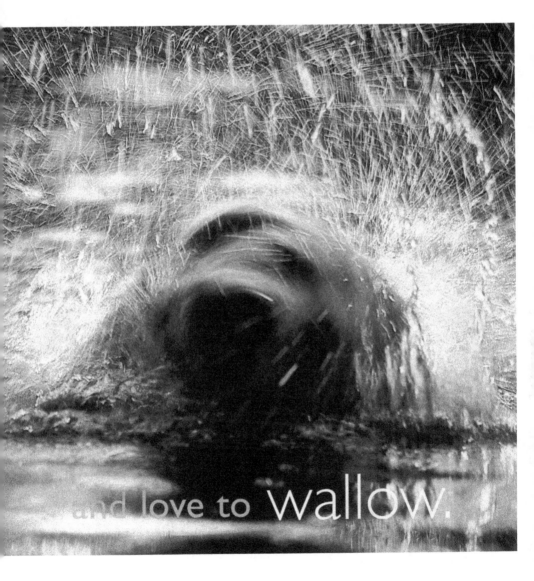
...and love to wallow.

How can Labs Love so much

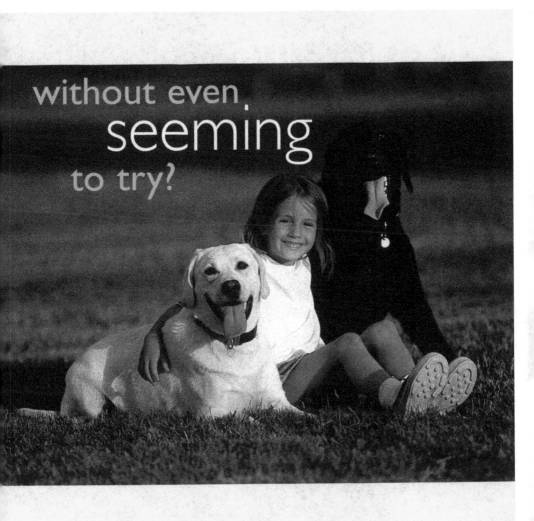
without even.
seeming
to try?

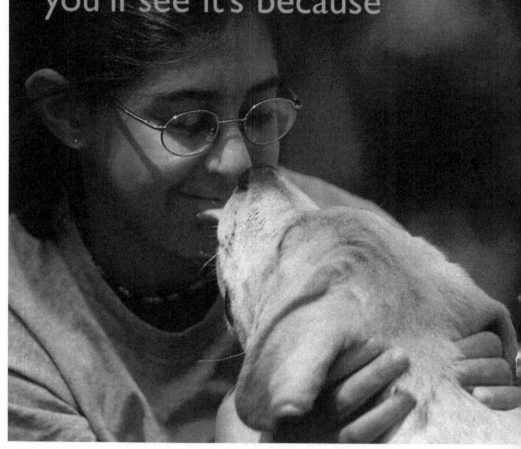

Share your life with a Lab, you'll see it's because

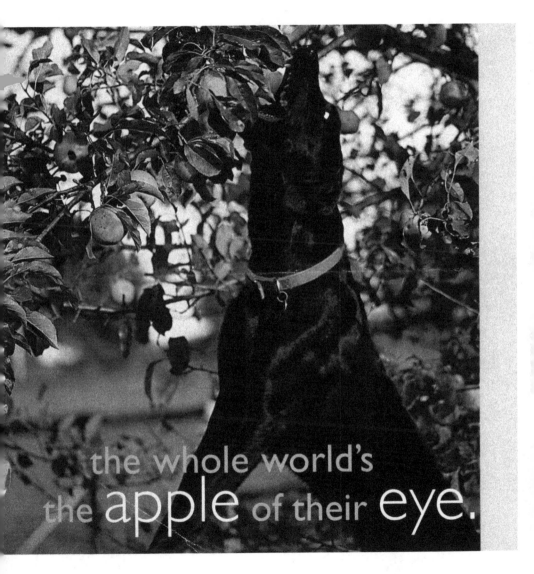

the whole world's
the apple of their eye.

Dedication

To Lucy, who taught me all there is about Labrador love.

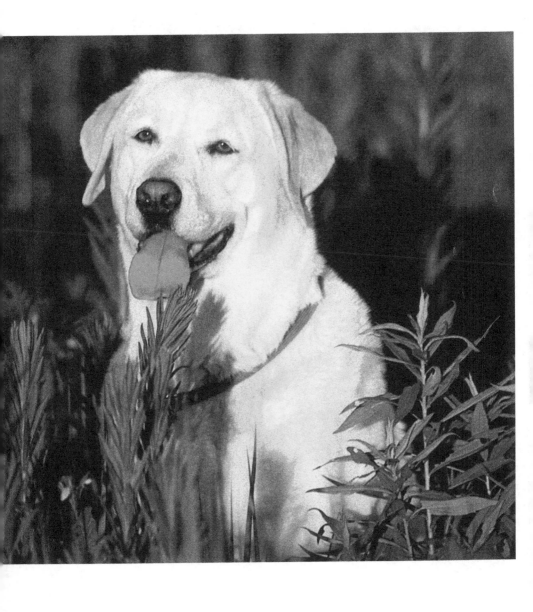

What (or who) does your

Place your Lab's photo here!

Lab Love....?

Place your Lab's photo here!

Labs Love
these great gift ideas

by Patricia Burlin Kennedy;
illustrated by Robert Christie

A heartwarming look at life through the eyes of
a Labrador Guide Dog puppy in training.

110 pages/40 original color paintings
$14.95/Can. $22.99; ISBN 0-87605-473-4.

by Patricia Burlin Kennedy;
illustrated by Robert Christie

Short, poetic observations and gorgeous
color paintings celebrate the Golden Retriever's
innate wisdom and charm.

122 pages/full-color illustrations throughout
$14.99/Can. $22.99; ISBN 0-7645-6131-6.

from Howell Book House

by Joel Walton and Eve Adamson

The smartest way to learn about your Lab is with this *For Dummies®* book. With compassion and humor, it answers all your fundamental questions and guides you through every stage of your Lab's life.

260 pages/illustrated with an 8-page color insert
$15.99/Can. $23.99; ISBN 0-7645-5281-3.

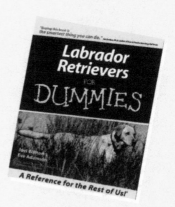

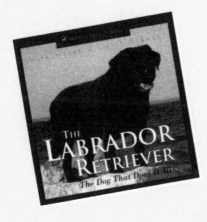

by Lisa Weiss

For the serious breeder and novice alike, we present the most comprehensive book on choosing, raising, and training the most popular dog in America. The dog that does it all now has a book that does it all.

224 pages/full-color photos throughout
$27.99/Can. $41.99; ISBN 0-87605-044-5.

Printed in the USA
CPSIA information can be obtained
at www.ICGtesting.com
JSHW012011140824
68134JS00023B/2370

9 781620 457252